D1350902

# THE STORY OF MR SOMMER

## PATRICK SÜSKIND

Translated by Michael Hofmann

Drawings by Sempé

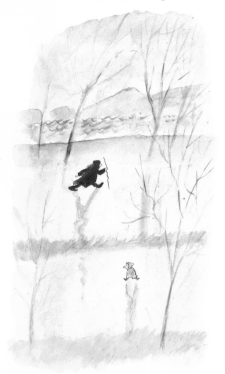

BLOOMSBURY

First published in Great Britain 1992
Copyright © 1991 by Patrick Süskind
Copyright © 1992 by Michael Hofmann

The moral rights of the author and
the translator have been asserted

Bloomsbury Publishing Ltd,
2 Soho Square, London W1V 5DE

ISBN 0 7475 1308 2

All drawings by Jean-Jacques Sempé

Typeset by Hewer Text Composition Services, Edinburgh
Printed by Butler & Tanner, Frome

In my old tree-climbing days – a long time ago now, many many years have passed since then, I was just over three foot four, my shoe size was a child's ten, and I was so light I could fly – no, that's no exaggeration, I really could fly – or nearly, or let's say it was within my power to fly, if only I'd put my mind to it and tried as hard as I could . . . I can clearly remember the time I all but flew, it was on an autumn day in my first year at school, and I was just on my way home from school, and there was such a strong wind blowing that without even spreading my arms I could lean into it at a sharp angle like a ski-jumper, or even more, without falling over . . . and when

I ran down the grassy slopes of School Hill into the wind – because the school was on a little hill outside the village – and I pushed off just a little way with my feet and spread my arms, then the wind lifted me up, and I could quite easily jump five or ten feet up in the air and twenty or thirty over the ground – or maybe not quite as high and as far, but what's it matter! – anyway, I was *almost* flying, and if I'd just unbuttoned my coat then and held my coat tails in both hands and spread them like wings, why, then the wind would have picked me up altogether, and I would have soared off School Hill with the greatest of ease, across the valley down to the woods, and then across the woods down to the lake where our house stood, and there, to the boundless astonishment of my father, my mother, my brother and my sister, all of whom were far too old and heavy to fly, I would have executed a stylish loop over the garden and swung out over the lake, going almost to the opposite shore before finally

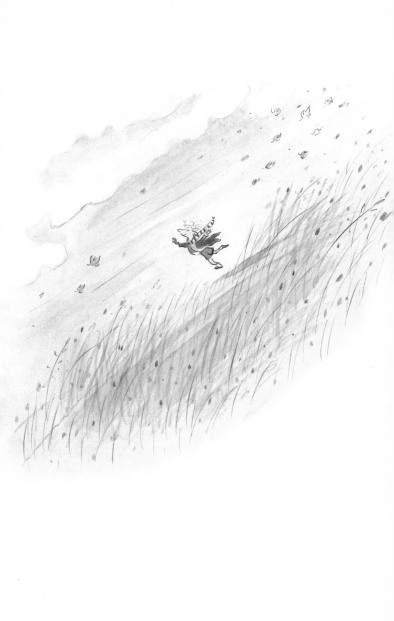

leisurely letting myself be wafted back, and still be home in time for lunch.

But I didn't unbutton my coat and I didn't really soar up into the air. Not because I was afraid of flying, but because I didn't know how and where and even whether I'd be able to land again. The paved terrace in front of our house was too hard, the garden was too small, the water in the lake too cold. Taking off was no problem. But how to get down again?

It was like that with climbing trees too: getting up them was the easy bit. You could see the branches ahead of you at eye-level, you could feel them with your hands and check how strong they were before entrusting yourself to them. But on the way down, you couldn't see anything, and you could only more or less blindly poke your feet around among the branches below before you found solid footing, which often enough turned out not to be solid at all, but slippery or rotten, and you slid off it or crashed through it, and,

if you weren't holding on to another branch with both hands for all you were worth, then you would drop like a stone, in accordance with the Laws of Gravity which the Italian inventor Galileo Galilei discovered almost four hundred years ago, and which are still valid today.

It was in that same first year at school that I had my worst-ever fall, falling fifteen feet off a white fir. It followed precisely the course prescribed by Galileo's First Law of Gravity, which says that the distance fallen equals half the product of gravity by time squared ($d = \frac{1}{2} g \times t^2$), and thus it took exactly 0.9578262 seconds, which is a very short time indeed – less than the time it takes to count from twenty-one to twenty-two, in fact less than it takes even to say twenty-two properly! It all happened so amazingly quickly that I couldn't get around to spreading my arms, or undoing my coat to use it as a parachute, yes, there wasn't even time for the saving thought to occur to me

that I didn't actually *need* to fall, seeing as I could fly – no, in that 0.9578262 of a second I couldn't think anything at all, and before I even realised I was falling, I hurtled to the ground – following the second of Galileo's Laws ($v = g \times t$) – with a final velocity of almost twenty miles per hour, and with such force that on the way the back of my head smashed through a branch that was at least two inches thick. The force that was responsible for all this was gravity. It doesn't just hold the planet together, it also has the peculiar property of attracting anything, big or small, to itself by brute force; it seems the only times we're ever free of its influence is when we're swimming under water or in the womb. In addition to this compelling insight into gravity's workings, I came away with a sizeable bump on my head. Within a few weeks the bump had gone, but in later years I would still feel a strange tingling and throbbing in the same place, whenever the weather turned and especially when there

was snow on the way. Today, almost forty years later, the back of my head remains an excellent barometer, more reliable than the weatherman when it comes to predicting rain or snow, fine weather or an upcoming storm. I also believe that a certain mental fogginess, an inability to concentrate, that has recently troubled me may be a delayed consequence of that fall from the white fir. For instance, I find it increasingly difficult to stick to the subject, or to express an idea clearly and simply, and when I'm telling a story like the present one, then I find I really have to be on my guard lest I lose the thread, otherwise I find myself getting bogged down in detail, and end up forgetting what I was talking about.

So, in my tree-climbing days – and don't get me wrong, I was a good and experienced climber, I didn't just keep taking tumbles! – I could even climb trees that had no low branches, trees you could only climb by gripping the trunk with your knees and hauling yourself up after, and I could climb

from one tree to another, and I built myself countless tree dens and a proper treehouse with mod cons like a roof and windows and a carpet on the floor, thirty feet up in the middle of the woods, when I think about it, I think I spent most of my childhood in trees, that's where I learned English vocab and irregular Latin verbs and maths formulae and physics laws, like the aforementioned Galileo Galilei's Laws of Gravity, all of it in trees, I did my homework, both oral and written, up trees, and I loved peeing from trees, in a high arc that pattered down through layers of leaves or needles.

It was peaceful up in the treetops, and you were left in peace there. No distracting calls from my mother, no peremptory summons from my older brother could reach me there, there was just the wind and the rustling of the leaves and the soft creaking of the treetrunk . . . and the views, the wonderful, panoramic views: not only could I see our own house and garden, I could see all the other houses and

gardens, I could see across the lake and the far shore of the lake as far as the mountains, and when the sun was setting in the evening, then from up in my treetop I could even see it going down beyond the mountains long after it had ceased to be visible to people on the ground. It was almost as good as flying. Not quite as thrilling and maybe not quite as stylish, but a good substitute all the same, especially as I was slowly getting older, I was now three foot ten and I weighed three and a half stone, and that was simply too much for flying, even if there was a real gale blowing and I unbuttoned my coat and held it open as far as it would go. But climbing trees – so I thought – that was something I'd be able to do all my life. Even at the grand old age of a hundred and twenty, as a doddery old man, I would still be sitting up there, in the top of an elm or a beech or a fir, like some ancient monkey, swaying gently in the breeze, and staring out across the land and the water, to the mountains and beyond . . .

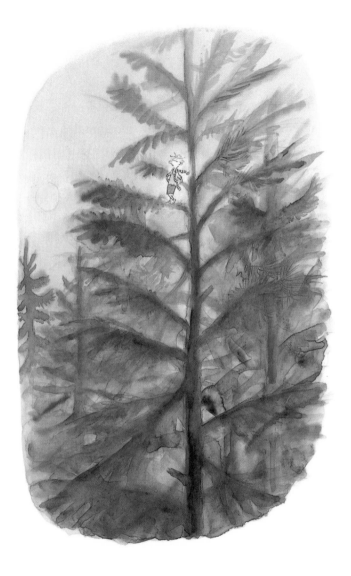

But what am I doing, talking about flying and climbing trees! Rabbiting on about Galileo Galilei and his Laws of Gravity and the barometric spot on the back of my head that makes me feel muddled! I meant to tell you about something completely different, namely the story of Mr Sommer – insofar as that's possible at all, because there isn't really a story as such, just a strange human being whose life crossed paths with mine – quite literally – a few times. I suppose I should really start again from the very beginning.

In my old tree-climbing days, there lived in our village . . . or rather not precisely in our own village of Unternsee, more in the next-door village of Obernsee, although it wasn't really as hard and fast as that, because Obernsee and Unternsee and all the other villages weren't really separate entities, there was a whole line of them, running along the shore of the lake, one after another, without any obvious beginnings and endings, a narrow chain of gardens and houses

and farms and boathouses . . . Anyway, in that part of the world, barely a mile away from our house, there lived a man we knew as 'Mr Sommer'. No one had the faintest idea what Mr Sommer's first name might be, Peter or Paul or Heinrich or Franz-Xaver, or if he was Dr Sommer or Professor Sommer – he was known purely and simply as 'Mr Sommer'. Nor did anyone know whether Mr Sommer followed any trade or profession, or even if he had a trade or profession, or had ever had one. All that was known was that Mrs Sommer followed a trade, which was that of doll-maker. Day in day out, she sat in the Sommers' flat, in the basement of the painter and decorator Stanglmeier's house, and manufactured little dolls for children out of wool, cloth and wood shavings. Once a week she would wrap up the dolls she'd made in a big parcel and take it along to the post office. On the way home from the post office she would go to the grocer, the baker, the butcher and the greengrocer, one after

the other, and arrive home with four bulging shopping bags, and then stay at home for the rest of the week, making more dolls. No one knew where the Sommers came from. They had simply arrived one day – she on the bus, he on foot – and since that day they'd lived in the village. They had no children, no relations, and no one ever came to visit them.

Although we knew next to nothing about the Sommers, and especially Mr Sommer, it would be true to say that Mr Sommer was then far and away the best-known man in the whole area. For in a radius of at least forty miles of the lake, there was no one, man, woman or child – or even dog – to whom Mr Sommer wasn't a familiar figure, because Mr Sommer was continually out walking. From early in the morning till late at night, Mr Sommer would be walking. Not a day would pass that didn't find Mr Sommer doing his rounds. It might be hailing or snowing, blowing a gale or bucketing with rain, there

might be a scorching sun or a storm in the offing, in all weathers Mr Sommer would be out and about. He would often leave home before daybreak, as the fishermen who went out on the lake at four in the morning to take in their nets would confirm, and often not get home till late at night, when the moon was already high in the sky. In that time, he would cover astonishing distances. To walk right the way round the lake, a distance of some twenty-five miles, in the course of a single day, was nothing out of the ordinary for Mr Sommer. To make two or three trips into town in a day, six miles each way – no problem for Mr Sommer! When we trotted off to school at half-past seven in the morning, still rubbing the sleep from our eyes, we would encounter a fresh and alert-looking Mr Sommer who had already been walking for hours; coming home tired and hungry at lunchtime, we would be overtaken by Mr Sommer, eating up the ground with enormous strides; and on the evening of the same day,

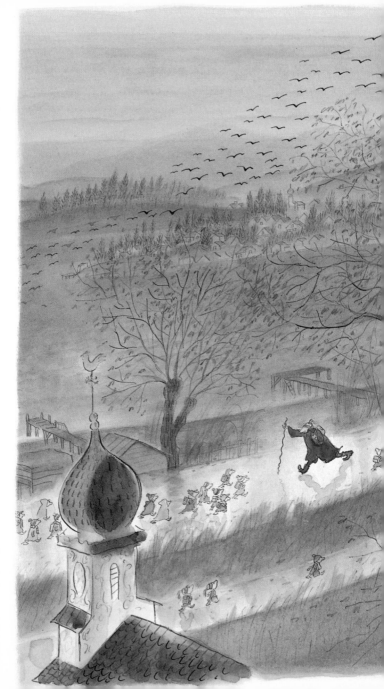

when I took a last peep out of the window before going to bed, I might see the tall, lanky figure of Mr Sommer hurrying shadowily by on the lake road.

He was very distinctive. Even from a distance, his appearance was unmistakable. In winter, he would wear a long, black, flapping and strangely stiff overcoat, which shifted on his body like a loose piece of armour or carapace, and with it he wore a pair of Wellington boots and a red, woollen bobble hat. But in summer – and for Mr Sommer, the summer took up most of the year, lasting from the beginning of March to the end of October – then Mr Sommer would wear a flat straw boater with a black ribbon, a caramel-coloured linen shirt and a pair of caramel-coloured shorts from which his long, wiry legs, all veins and sinews, emerged, looking ridiculously skinny, before disappearing into a pair of stout climbing boots. In March these legs would be dazzling-white with the veins etched into them in

inky blue like a complicated river-system; but even a fortnight later, they would be honey-coloured, by July they would have the same caramel colour as his shirt and shorts, and by the autumn they would have been so tanned by sun, wind and weather that you couldn't tell the veins from the muscles or sinews, Mr Sommer's legs would look like the knobbly branches of an old barked pine tree, and then in November they would be tucked away out of sight under the long, black greatcoat until the following spring when they would re-emerge in their original milky pallor.

There were two items that accompanied Mr Sommer all the year round, and without which he was never seen: one was his stick, the other his rucksack. The stick was no common-or-garden walking stick, but a long, slightly undulating hazel staff that reached up past Mr Sommer's shoulders, and which served him as a kind of third leg, without whose assistance he could never have attained

such extraordinary speeds or covered such incredible distances, many times greater than those of a normal walker. Every third step he took, Mr Sommer would swing the stick out in front of him with his right hand, jab it into the ground, and push himself past it with all his strength, so that it looked for all the world as though his legs were just paddling along in his slipstream, whereas the real propulsion came from the strength of his right arm, transmitted via the stick to the ground – not unlike some river-boatmen who propel their flat-bottomed boats with long poles. The rucksack, for its part, was always empty, or almost empty, because so far as anyone knew it contained nothing but a sandwich for Mr Sommer's lunch and a rolled-up waterproof cape with a hood, which Mr Sommer would put on if he was ever caught out by a shower.

Where did his wanderings take him? What was the point of his endless marches? To what purpose did Mr Sommer hurry through the

countryside for twelve, fourteen or sixteen hours a day? Nobody knew.

Shortly after the War, at the time the Sommers first arrived in the village, such expeditions hadn't attracted much attention, because just about everyone was then crisscrossing the countryside with rucksacks. There was no petrol and no cars, a bus just once a day, and nothing to burn and nothing to eat, and in order to get hold of a couple of eggs or some flour or potatoes or a few lumps of charcoal or just some writing paper or razor blades, people often had to trek for hours, and lugged home whatever they'd managed to get in a handcart or a rucksack. But just a couple of years later, you could buy anything you needed in the village, coal was delivered, and there were five buses a day. A few years after that, the butcher owned his own car, and then the burgomaster and the dentist followed suit, and the painter Stanglmeier rode around on a motor bike and his son on a moped, and the bus still came three times

a day, and no one would have dreamed of tramping four hours into town now if he had some business there or needed to renew his passport or something like that. No one but Mr Sommer. Mr Sommer walked as he had always walked. In the morning he strapped on his rucksack, picked up his stick and hurried off across fields and meadows, on highways and byways, through the woods and round the lake, into town and back, from village to village . . . till late at night.

The peculiar thing about it all was that he never ran any kind of errands. He bought nothing and delivered nothing. His rucksack remained empty, but for his sandwich and his cape. He didn't go to the post office or the council offices, he left all that to his wife. He paid no calls and didn't stop off anywhere. When he went into town, he didn't go into the pub for a bite to eat or a glass of something, yes, he didn't so much as sit on a bench to rest for a minute or two, but turned on his heel and headed straight home again, or wherever

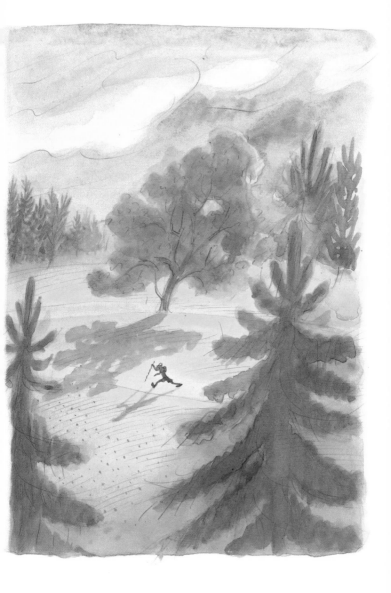

else he was going. If you asked him, 'Where have you just come from, Mr Sommer?' or, 'Where are you headed for?' he would shake his head irritably, as though a fly were perched on his nose, and mumble something to himself that was either completely incomprehensible or almost so, something that sounded like: 'justgoingupschoolhillcan'tstop . . . quicktourroundthelake . . . gottogointotowntodayabsolutelyessential . . . verypushedjustnowmustbegettingon . . . ' and before you could say, What was that? I'm sorry? Where? he had already rushed past, with violent hoeing motions of his stick.

There was one occasion and one occasion only when I heard Mr Sommer say a whole sentence. It was a clearly and distinctly and unmistakably enunciated sentence, and I have never forgotten it, to this day I can hear it echoing in my head. It was on a Sunday afternoon at the end of July, during an appalling cloudburst. The day had begun pleasantly enough, gloriously, in fact, with

hardly a cloud in the sky, and at noon it was still so hot that all you wanted to do was drink glass after glass of iced tea with lemon. My father had taken me along to the races, as he often did on Sundays, because he used to go racing every Sunday. Not to bet, by the way – I should like to make that clear – but out of sheer devotion to the sport. Although he had never in his life sat on a horse, he was an enthusiastic lover and connoisseur of horseflesh. For instance, he had memorised the names of all the winners of the German Derby since 1869, in chronological and reverse order, and also the most important winners of the English Derby and the French Prix de l'Arc de Triomphe since 1910. He knew which horses were mudlarks, and which preferred firmer ground, why older horses went over jumps, while young ones never ran more than a mile, knew how many pounds the jockeys weighed, and why the owner's wife wore a red-and-green-and-gold ribbon on her hat.

His equine library contained five hundred volumes, and towards the end of his life he even owned a horse – half of one, actually – which, to my mother's horror, he had bought for six thousand marks, to have it run in his colours – but that's another story which I'll keep for another occasion.

So we'd been to the races, and as we drove home in the late afternoon, it was still hot, in fact it was even hotter and stickier than it had been at lunchtime, but the sky was already veiled by a thin haze. There were leaden clouds in the west, with pus-yellow rims. After a quarter of an hour, my father had to switch on the headlights, because the clouds had suddenly gathered and obscured the horizon, so that the whole countryside was in shadow. Then a few gusts swept down from the hills and moved through the cornfields in broad sweeps, it was as though the fields were being combed, and the shrubs and bushes took fright. At the same time almost, the rain began, no, not

real rain yet, but a few enormous, isolated drops, the size of grapes, splattered down on the tarmac and burst against the radiator and the windscreen. Then the storm broke. It said in the newspapers later that it was the worst storm in the area for twenty-two years. I can't judge the truth of that because I was only seven at the time, but what I can say is that in all my life I have never experienced another storm like it, least of all while sitting in a car on the open road. The water didn't fall in drops, but simply sheeted down from the sky. In no time at all, the road was awash. The car ploughed through the water, throwing up fountains on either side, and there seemed to be a constant layer of water on the windscreen, even though the windscreen wiper was beating wildly back and forth.

It got worse. By and by the rain turned to hail, you could hear the difference before you saw it, the whooshing had turned into a harder clicking and rattling, and you felt

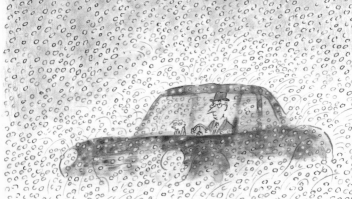

it too because the car was in the grip of a frosty chill. Then we saw the hailstones, no bigger than pinheads at first, then the size of peas, of marbles, and finally whole swarms of smooth, white golfballs were clattering down and bouncing back off the bonnet, in such wild, whirling confusion it made you giddy to watch. It was impossible to drive another yard, my father pulled over to the side of the road – side of the road, you couldn't even see the road, still less where it stopped, a bit of a field or tree or anything else, you could barely see five feet in front of you, and in those five feet there were simply millions and millions of icy billiard balls whirling through the air and making a horrific clatter as they smashed into the car. Inside, the din was such that it was impossible to talk. We sat there as though inside a huge drum on which a giant was beating a drumroll, just looking at one another and shivering and silently hoping our protective casing wouldn't be destroyed.

Within two minutes it was all over. From

one instant to the next, the hail had stopped
and the wind abated. Now there was only a
fine drizzle coming down. The cornfield by
the side of the road where the gusts had come
down earlier was completely flattened. There
was nothing left of the maizefield behind
it but a few stalks. The road looked as
though it had been strewn with broken
glass – as far as the eye could see, smashed
hailstones, leaves, snapped twigs and ears of
corn. Right at the end of the road I could
see, dimmed by the drizzle, the form of a
man walking away from us. I pointed him
out to my father, and together we looked at
the small, distant form, and it seemed like
a miracle to us that somebody should be
out of doors, walking, yes, even the fact
that someone was still upright when all
around had been flattened and demolished.
We drove off, crunching over the hailstones.
As we approached the figure, I recognised the
shorts, the long, knobbly-kneed, glistening
legs, the black cape pushed out at the back by

the outline of a rucksack, and Mr Sommer's furious walk.

We caught up with him, my father told me to wind down the window – the air outside was ice-cold. 'Mr Sommer!' he called out. 'Climb in! We'll give you a lift!' and I scrambled into the back to make room for him on the passenger seat. Mr Sommer made no reply. He didn't even stop. He barely gave us a glance. With hasty strides, propelled by the hazel staff, he went on walking down the hailstrewn road. My father drove after him. 'Mr Sommer!' he called through the open window. 'Please get in! In this weather! We'll run you home!'

But Mr Sommer didn't respond. Undaunted, he walked on. It seemed to me I saw his lips moving, making one of his inaudible replies. But I heard nothing, so perhaps it was just that his lips were trembling with the cold. Then my father leaned right across the front seat and – all the time he was driving along beside Mr Sommer – held open the passenger

door and shouted, 'Now, for God's sake, get in! You're soaked to the skin! You'll catch your death of cold!'

Now, the expression 'You'll catch your death of cold!' was actually very uncharacteristic of my father. I had never heard him seriously say to anyone, 'You'll catch your death of cold!' 'That expression is a cliché,' he would say, if he happened to hear or read it somewhere, 'and a cliché – I'm telling you once and for all – is an expression that has been used so often aloud and in print, by every Tom, Dick and Harry, that it's become completely devoid of meaning. It's just as' – he continued, by now firmly on one of his hobbyhorses – 'it's just as bland and idiotic as the sentence "Have a nice cup of tea, my dear, and that'll set you to rights!" or, "How's our patient doing then, doctor? Do you think he'll pull through?" Sentences like that don't come from life, but from bad novels and silly films, and that's why – I'm telling you once and for all – I

never want to hear that sort of thing pass your lips!'

That was what my father thought of sentences like 'You'll catch your death of cold!' But now, driving on the hailstrewn country road, in a thin drizzle, alongside Mr Sommer, there was my father shouting one of these very clichés through the open passenger door: 'You'll catch your death of cold!' And then Mr Sommer stopped. I think he stopped just when he heard the words 'death of cold', he froze, so suddenly that my father hurriedly had to put the brakes on so as not to drive past him. And then Mr Sommer transferred his hazel stick from his right hand to his left, turned towards us, and, ramming the stick repeatedly into the ground with an air of stubbornness and exasperation, he blurted out, loud and clear, the following sentence: 'Why don't you just leave me in peace!' That was all. Just that one sentence. Then he slammed the passenger door shut, transferred his stick back into his right

hand, and marched off, without a single look back.

'The fellow's completely mad,' said my father.

When we passed him, I could look into his face through the rear window. He was keeping his eyes to the ground, but lifting them with every few steps in order to check his bearings – wide-open, terrified eyes. The water flowed down his cheeks and dripped from his nose and chin. His mouth was slightly open. Once again, it seemed to me his lips were moving. Perhaps he was talking to himself as he walked.

'Mr Sommer suffers from claustrophobia,' said my mother, once we were all sitting down to supper and talking about the storm and the incident with Mr Sommer. 'He's got a serious case of claustrophobia, which is a kind of illness that makes it impossible to sit quietly in your room.'

'Strictly speaking,' said my father, 'claustrophobia means – '

'That you can't sit quietly in your room,' said my mother. 'Dr Luchterhand explained it to me.'

'The word "claustrophobia" is of Latin and Greek origin,' said my father. 'As I'm sure Dr Luchterhand is well aware. It's made up

of two parts, "claustrum" and "phobia". "Claustrum" means "shut" or "locked" – as in the word "closet", or the name of the town of Klausen, Italian "*chiusa*" or the French "*Vaucluse*" – can any of you give me another example of a word that has "claustrum" in it?'

'Actually,' said my sister, 'I heard from Rita Stanglmeier that Mr Sommer has a terrible twitch. He twitches all over his body. He's as bad as Fidgety Philip, Rita says. The minute he sits down on a chair, he starts twitching. It's only while he's walking that he doesn't twitch, and that's why he has to keep on walking, so that no one can see him twitch.'

'That's something he has in common with yearlings,' said my father, 'or two year olds, who tremble all over with nerves when they're about to run a race for the first time. Their jockeys have really got their hands full to keep them from boring at the start. Later on, they either seem to grow out of it, or they're made

to wear blinkers. Which of you can tell me what "boring" means?'

'Nonsense!' said my mother. 'In the car with you, Mr Sommer could have twitched away if he had to. You wouldn't have minded him twitching a bit!'

'I'm afraid,' my father said, 'that the reason Mr Sommer didn't accept a lift from us was because I used a cliché. I said, "You'll catch your death of cold!" I can't understand how such a thing can have happened to me. I'm sure he would have come along happily if I'd used a less hackneyed expression, such as . . .'

'Rubbish!' said my mother. 'He didn't get in because he's claustrophobic, and that means he's no more capable of sitting in a closed car than a room. Ask Dr Luchterhand! As soon as he finds himself in any enclosed space – whether it's a car or a room – he has attacks.'

'What attacks?' I asked.

'Maybe,' said my brother, who was five

years older than I, and had read all of *Grimms'*
*Fairy-Tales* already, 'maybe Mr Sommer is
like the walker in the fairy-tale "How Six
Travelled through the World", who can go
round the whole world in one day. When he
gets home, he has to tie up one of his legs
with a leather strap because it's the only way
he can stop.'

'Of course that's another possibility to be
considered,' said my father. 'Perhaps Mr
Sommer has just got one leg too many, and
that makes him keep going. We should ask
Dr Luchterhand to tie up one of his legs.'

'Nonsense,' said my mother, 'he's claus-
trophobic, that's all there is to it, and there's
nothing you can do about claustrophobia.'

As I lay in bed, that strange word ran
through my head for a long time: claustro-
phobia. I said it to myself over and over,
so that I might never forget it: 'Claustro-
phobia ... Claustrophobia ... Mr Sommer
has claustrophobia ... That means he can't
stay in his room ... and the fact that he

The word 'claustrophobia' is of Latin and Greek origin... It means 'shut' or 'locked'... Claustrophobia is a kind of illness that makes it impossible to sit quietly in your room.

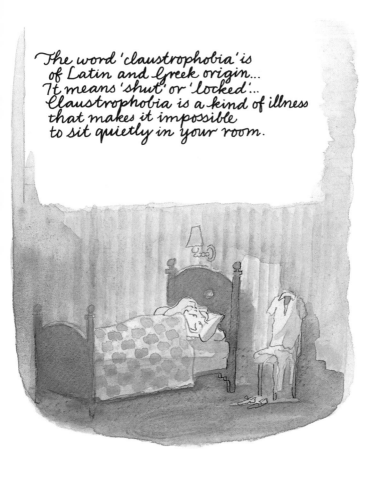

can't stay in his room means that he's got to keep going for walks … Because he's got claustrophobia, he has to keep going for walks … But if "claustrophobia" is the same as "not-being-able-to-stay-in-your-room", and "not-being-able-to-stay-in-your-room" is the same as "having-to-keep-going-for-walks", then "having-to-keep-going-for-walks" must be the same as "claustrophobia" … and then instead of that hard word "claustrophobia" you could as well say "having-to-go-for-walks" … But that would mean that when Mother says, "Mr Sommer has to keep going for walks because he suffers from claustrophobia," she might just as well have said, "Mr Sommer has to keep going for walks because he has to keep going for walks" … '

And with that I started to feel rather dizzy in my head, so I hurriedly tried to forget this mad new word and everything connected with it. Instead, I tried to think of Mr Sommer as not suffering from any illness or condition,

but just going for walks because he enjoyed going for walks, the way I enjoyed climbing trees. It was for his own pleasure and delight that Mr Sommer went for walks, that's all it was and nothing else, and all the bewildering explanations and the Latin words that the grown-ups had come up with over supper were as spurious as the business of tying up your leg in the fairy-tale 'How Six Travelled through the World'!

After a time, though, I remembered Mr Sommer's face when I'd seen it through the rear window, his rain-dripping face with half-open mouth and enormous eyes with their ghastly expression, and I thought: You don't look like that for fun; no one looks like that when he's just doing something for fun and because he enjoys it. That's the expression of someone who's terrified; or someone who's thirsty, who's walking in the rain but feels such a thirst in him he could drink a whole lake. And once more I felt dizzy, and I tried as hard as I could to forget Mr Sommer's face,

but the harder I tried to forget it, the more vividly I could picture it to myself: I could see its every wrinkle and line, every bead of sweat and drop of rain, the faint trembling of the lips, seeming to mumble something. And the mumbling grew louder and more distinct, and I could hear Mr Sommer's voice saying imploringly, 'Why don't you leave me in peace! Can't you just leave me in peace . . . !'

And it was only now, when I heard his voice, that I could stop thinking about him. His face vanished, and I quickly fell asleep.

In my class at school there was a girl called Carolina Kückelmann. She had dark eyes, dark eyebrows and dark-brown hair which she wore with a slide over her right temple. On the back of her neck and in the little hollow between her earlobe and her throat, her skin had a light, downy fluff on it, which shone in the sunlight and sometimes just stirred in the wind. When she laughed, with her wonderfully throaty voice, she threw her head right back and her whole face would beam with merriment, so that her eyes were almost closed. I could have gone on looking at that face for ever, and I did look at it whenever I could, in

47

lessons or during break. But I was careful to do it discreetly, so that no one saw me looking, not even Carolina herself, because I was terribly shy.

In my dreams I wasn't so shy. There I would take her by the hand and lead her into the woods and climb trees with her. Sitting beside her on a branch, I would gaze into her face from very close, and tell her stories. She would laugh, throw her head back and close her eyes, and I was allowed to blow on the fluffy hairs on her neck and in front of her ears. I had such dreams several times a week. I'm not complaining, they were beautiful dreams, but they were just dreams, and like all dreams they couldn't ever be really satisfying. I would have given anything to have Carolina with me in reality, just once, and blow on her neck or whatever ... Unfortunately there was very little prospect of that ever happening, because, like most of the class, Carolina lived in Obernsee, while I was the only one

who lived in Unternsee. Our ways parted just outside the school gates, and went in opposite directions down School Hill across the meadow and into the woods, and, by the time they disappeared into the woods, they were already so far apart that I could not identify Carolina among the group of the other children. Only sometimes I would still be able to pick up her laughter. In certain weathers, when the wind blew from the south, her throaty laughter would carry across the fields to me and accompany me all the way home. But when did we ever have a south wind!

One day – a Saturday – a miracle occurred. Bang in the middle of break, Carolina came running up, stopped in front of me and said, 'Hey! You're always going to Unternsee by yourself, aren't you?'

'Yes,' I said.

'Well! On Monday I'll be coming with you . . . '

And then she added a lot of explanation,

there was a friend of her mother's who lived in Unternsee, and then her mother would come over to pick her up from this friend's house, and then she and her mother, or she and the mother's friend, or she and her mother *and* her mother's friend ... I can't remember, I've forgotten, and I think even as she was telling me it went in one ear and out the other, because I was so amazed, so overcome by her saying, 'On Monday I'll be coming with you!' that I didn't or couldn't take in anything else, just that one wonderful sentence: 'On Monday I'll be coming with you!'

For the rest of the day, in fact, for the whole weekend, that sentence kept sounding in my ear, it sounded so wonderful – ah, come on! it sounded more wonderful than anything I'd read in the Brothers Grimm, more wonderful than the promise of the princess in 'The Frog Prince' where she says, 'Eat from my little golden plate, and drink out of my cup, and sleep in my little bed,' and I counted

the days with still greater impatience than Rumpelstiltskin:

Today I stew, and then I'll bake
Tomorrow I shall the Queen's child take!

I felt like Hans in Luck and Brother Lustig and the King of the Golden Mountain all rolled into one ... 'On Monday I'll be coming with you!'

I made preparations. On Saturday and Sunday I combed the woods to find the most fitting route. Because it was obvious that I couldn't just take Carolina my usual way. I wanted her to try out my most secret paths with me, I wanted to show her my most hidden, out-of-the-way sights. The way to Obernsee was to pale in her memory, compared to the wonders she would be shown on my, or rather on our, way to Unternsee.

After long deliberation I fixed on a route that turned off the road just after the woods began, went through a narrow defile up to a plantation of young fir trees, and from there

over mossy ground to a deciduous wood, before making quite a steep descent to the lake. This route boasted no fewer than six sights that I proposed to show Carolina, with the benefit of an expert commentary from myself. These were, in order, as follows:

a) a transformer hut belonging to the electricity company, just off the main road, which emitted a continuous buzz, and whose door had a yellow sign on it with a red lightning flash and the words: 'Caution – High Voltage – Danger of Death!';

b) a clump of seven raspberry bushes including some ripe berries;

c) a manger for deer – presently without any hay in it, but with a big salt lickstone instead;

d) a tree that an old Nazi was supposed to have hanged himself from shortly after the War;

e) an anthill four feet across and almost three feet high, and, finally, the last, crowning item on the tour;

f) a superb old beech tree which I intended to

climb with Carolina, with a big fork in it about thirty feet up, from where we would have an incomparable view of the lake, and I might lean across to her and blow on her neck.

I pilfered a packet of biscuits from the kitchen cupboard, a jar of yoghurt from the fridge, and a couple of apples and a bottle of blackcurrant juice from the cellar. I packed all of that up in a shoebox, and left it up in the fork on Sunday afternoon, so that we'd have some provisions waiting for us. In bed that night I made up the stories I would tell Carolina to make her laugh, one story for the walk, the other for our sojourn in the beech tree. I switched the light on again, took a little screwdriver from the drawer of my bedside table and put it in my school satchel, as one of my most prized possessions, to be presented to her when we parted tomorrow. Back in bed again, I went over both stories, went over the agenda for the next day in considerable detail, went through the stops on the way from a) to f) several times, and the time and place where I'd

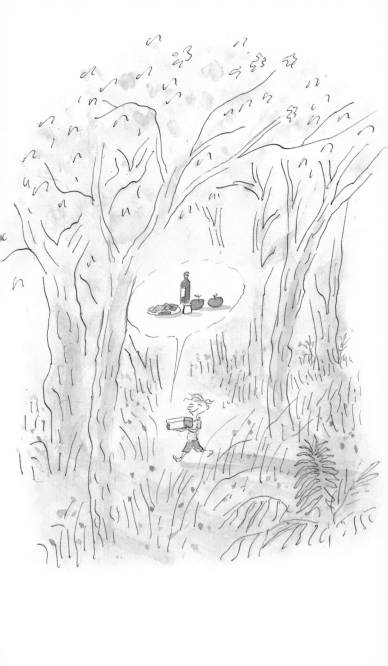

present her with the screwdriver, went over the contents of the shoebox which was even now lying out in the woods in the tree-fork, waiting for us – was ever a rendezvous more thoroughly prepared! – and finally I drifted off to sleep, accompanied by her sweet words, 'On Monday I'll be coming with you . . . On Monday I'll be coming with you . . . '

Monday when it dawned was a peach of a day, gentle sunshine, the sky clear and blue as water, the blackbirds singing and the sound of woodpeckers echoing through the woods. It was only now, as I was on my way to school, that I realised that in all my preparations I'd completely failed to make any allowance for the possibility of bad weather. My entire route from a) to f) would have been a disaster in rain or high wind – the raspberry bushes despoiled, an unsightly anthill, squeaky wet moss underfoot, the beech tree too slippery to climb, and my box of provisions either sodden or else completely blown away. I abandoned myself delightedly to these morbid imaginings, they

filled me with sweet, superfluous alarm, and gave me a positively triumphal sensation of happiness: not only had I not given the weather a moment's thought – no, the weather had gone out of its way in thinking about *me*! Not only was I allowed to accompany Carolina Kückelmann today – no, to cap it all, I was handed the finest day of the year for it too! Truly, I was a Sunday child. The kindly eye of the Creator rested on me personally. Only see – I thought to myself – that you don't kick over the traces while fortune smiles on you! Pride and overexuberance led to last-minute mistakes, it was always happening in fairy-tales, the heroes wrecked the happiness they thought was securely in their grasp!

I started walking faster. On no account did I want to be late for school. During lessons I behaved impeccably as never before, so that the teacher should not have the slightest pretext for possibly detaining me. I was both quiet and attentive, meek and smarmy, a proper model pupil. I didn't look across to

Carolina once, I compelled myself not to, not yet, I wouldn't allow myself, superstitiously almost, as though by a premature look I would jeopardise her . . .

When school was finished, it turned out that the girls had to stay behind for an hour, I can't remember why, maybe it was for needlework or something. At any rate, only we boys were let out. I wasn't at all put out by that – quite the opposite. I thought of it as an additional test for me, one that I would pass with flying colours, and it also gave the long-awaited assignation with Carolina a kind of special distinction: we would have waited a whole extra hour for each other!

I waited at the parting of the ways to Obernsee and Unternsee, barely twenty yards beyond the school gates. There was a rock there, an erratic, a smooth slab that had broken off some larger mass. In the middle the rock bore a hollow indentation in the form of a hoof. People said this indentation had been caused by the Devil stamping his foot on the

ground with rage because the farmers had built a church near by, way back in the mists of time. I sat down on the rock and whiled away the minutes by flicking drops of water from a puddle that had formed in the Devil's print. The sun was warm on my back, the sky was still cloudless azure, I sat and waited and flicked water, I had nothing on my mind, and felt just incredibly happy with my situation.

At last the girls came out. First a whole surge of them rushed past me, and then, the last one of all, she. I got to my feet. She ran up to me, her dark hair flying, the slide in her bangs bouncing up and down, she had a lemon-yellow dress on, I held out my hand, she stopped in front of me, as close as she'd been that time in break, I wanted to reach out for her hand, I wanted to pull her to me, how I would have loved to give her a hug and kiss her smack in the middle of her face, she said, 'Hey! Were you waiting for me?'

'Yes,' I said.

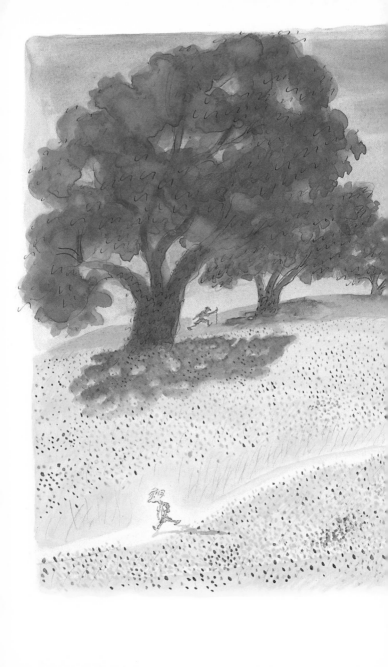

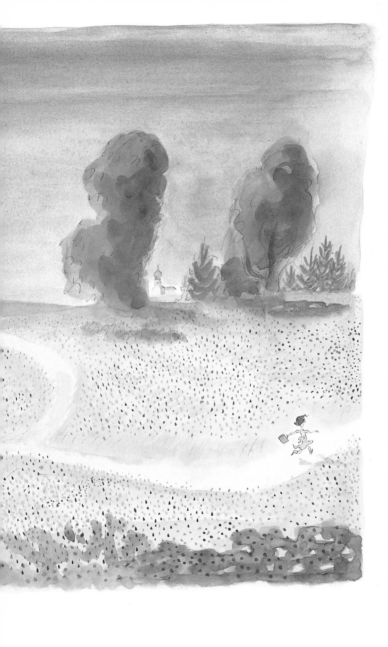

'Hey! I can't come with you after all. My mother's friend isn't well, and my mother won't be visiting her, and so my mother said I should . . . '

And there followed a lengthy explanation that I mostly didn't even hear, let alone take in, because I suddenly had a strange feeling of deafness in my head and unsteadiness in my legs, and the only thing I really remember is that when she'd said her piece she quickly spun on her heel and her lemon-yellow form ran off in the direction of Obernsee, very fast, to catch up with the other girls.

I headed for home down School Hill. I must have been walking very slowly, because by the time I reached the edge of the woods, and automatically looked across to the distant path to Obernsee, there was no one to be seen. I stopped, turned round and looked back up at the round outline of School Hill. The meadows lay full in the sun, not a breath of wind stirred the grass. The scene was one of absolute stillness.

And then I saw a little moving point. A dot, on the very left edge of the woods, making its way steadily across to the right, along the perimeter of the wood, up School Hill and along the top of it, along the crest, heading south. Silhouetted against the blue of the sky, though no bigger than an ant, you could clearly see it was a man. I recognised Mr Sommer by his three legs. Regular as clockwork, in tiny tick-tack steps, his legs hurried on, and the faraway dot slid – at once quickly and slowly, like the long hand of the clock – right across the horizon.

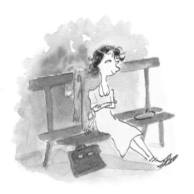

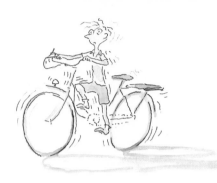

A year later, I learned how to ride a bicycle. That didn't exactly make me a prodigy because I was already four foot five, weighed five stone two pounds and had shoe size twelve and a half. But I had never been especially interested in cycling. That wobbling form of locomotion on nothing but two spindly wheels always struck me as deeply untrustworthy, yes, almost spooky, because no one was ever able to explain to me how a bicycle that falls over right away if it isn't held or propped or resting against something suddenly doesn't fall over when a five stone boy gets on to it and rides around on it without any form of support

or rest. The laws accounting for this extraordinary phenomenon, the gyroscopic laws and in particular the Law of the Conservation of Angular Momentum, were completely unknown to me at the time, even today I don't fully understand them, and the very words 'gyroscopic' and 'angular momentum' are a little alarming to me and confuse me to the extent that I feel the familiar itching and throbbing in the back of my head.

I daresay I would never have learned to ride a bicycle at all, if it hadn't been absolutely essential. But it became absolutely essential because I was to begin taking piano lessons. And the only person who gave piano lessons was a piano teacher who lived at the other end of Obernsee, which would have meant an hour's walk each way, but on a bicycle – my brother had it down to no more than thirteen and a half minutes.

It was the same piano teacher who had already taught my mother, my sister, my brother and everyone in the village who

could so much as depress a key – whether it was the church organ or Rita Stanglmeier's accordion – Marie-Luise Funkel was her name, *Miss* Marie-Luise Funkel. She placed great emphasis on that 'Miss', though I must say I have yet to see a female creature less Miss-like than Marie-Luise Funkel. She was ancient, white-haired, hunchbacked and wizened, with a little black moustache and no bosom whatsoever. I know, because once I saw her in her vest when I accidentally turned up for my lesson an hour early, and she hadn't yet finished her afternoon nap. There she was, standing in the doorway of her enormous old villa, wearing only a skirt and a vest, and not a soft, loose, silky ladies'-type vest but one of those light, sleeveless cotton singlets that we boys would wear for PE, from which her scrawny arms and her thin, leathery neck poked out – and underneath which her chest was as flat and skinny as a chicken breast. In spite of which – as I say – she would insist on

the 'Miss' before the 'Funkel', and, as she often explained, without ever being asked – because men might otherwise suppose she was already spoken for, whereas in fact she was still unmarried and open to offers. That explanation was of course absolute rubbish, because who in the world would ever marry old Miss Funkel with her flat chest and her moustache?

In fact, the real reason why Miss Funkel called herself 'Miss Funkel' was because she couldn't call herself 'Mrs Funkel', even if she'd wanted to, because there already was a Mrs Funkel . . . or should I say there still was a Mrs Funkel. This was Miss Funkel's mother. And if I said earlier that Miss Funkel was ancient, I don't know what words would do justice to Mrs Funkel: hoary, antique, prehistoric, old as the hills . . . I think she must have been at least a hundred. She was so old that really she was only alive in quite a narrow specialised sense, more like a piece of furniture, or a dusty

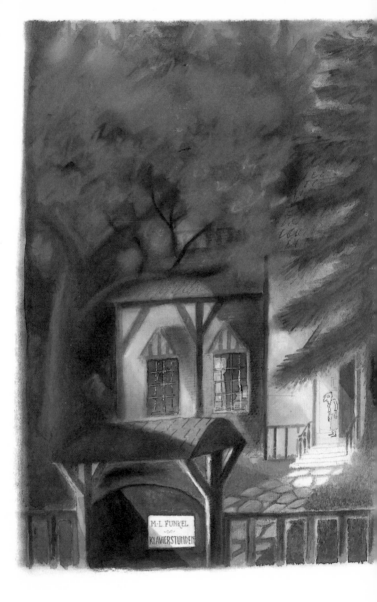

preserved butterfly or a delicate piece of china than a flesh-and-blood human being. She didn't move, she didn't speak, I don't know how well she could see or hear, I never saw her other than sitting. She would sit – in summer cocooned in white tulle, in winter draped in black velvet, with only her nodding tortoise head protruding – in a wing chair in the far corner of the music room, under a grandfather clock, silent, unmoving and disregarded. Only on some extremely rare occasions, when a pupil had done his homework especially well, and played his Czerny études without a single mistake, would Miss Funkel go out into the middle of the room when the hour was up, and shout in the direction of the wing chair, 'Ma!' – she called her mother 'Ma!' – 'Ma! Give the boy a biscuit, he's played very well today!' And then you would have to walk right across the room to the corner, stand in front of the wing chair, and hold out your hand to the ancient crone. Miss Funkel would call

out a second time, 'Give the boy a biscuit, Ma!' and then, indescribably slowly, a hand, a blue, frail, trembling hand would emerge from the tulle or velvet covering, and, with the tortoise head and eyes taking no part, would creep across the armrest of the chair and on to a low coffee table where there was a plate of biscuits, pick one up, usually a square wafer with a white cream filling, travel slowly back across the table holding the biscuit, over the armrest of the wing chair, across her lap to the child's extended hand, and with her bony fingers deposit it there like a gold coin. Sometimes it happened that the child's hand and the old woman's fingers brushed one another, and that qualmed you to the marrow, because you were expecting a cold and clammy touch, but what you got was a warm, even hot, and incredibly delicate, light, fleeting and shudder-inducing touch, like that of a bird fluttering out of your hand. Whereupon you mumbled your 'Thank you very much, Mrs Funkel', and hurtled out of

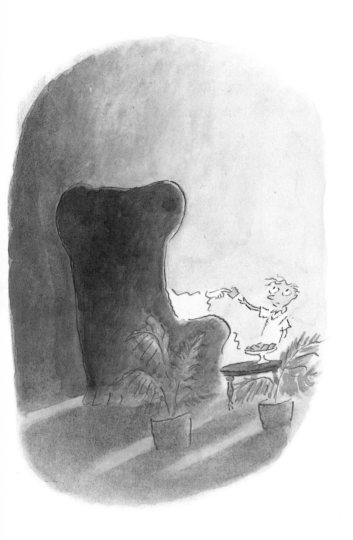

the room, away from the gloomy house, into the sunshine and the fresh air.

I don't remember how long it took me to master the dark art of riding a bicycle. All I remember is that I learned it by myself, with a mixture of unwillingness and grim resolve, on my mother's bicycle, on a slightly sloping forest track where no one could see me. The track was so narrow and steeply banked on either side that I could push off almost anywhere, and was assured of a soft landing on leaves and loose earth when I fell off. And one time, after many failed attempts, surprisingly suddenly really, I cracked it. I could move – in spite of all my theoretical doubts and my powerful scepticism – freely on two wheels: a mystifying and proud sensation! On the terrace of our house, and the adjacent lawn, I performed a demonstration ride in front of all the family, and was rewarded by applause from my parents and sarcastic hoots from my brother and sister. Subsequently, my brother acquainted me with the basic

traffic regulations, in particular with the rule that one should ride on the right at all times, right being defined as the same side as the one where the handbrake was mounted on the handlebar[1], and from that moment on, I rode once a week, all on my own, to piano lessons with Miss Funkel on Wednesday afternoon between three and four o'clock. Admittedly the thirteen and a half minutes my brother had estimated as the time for the distance was rather optimistic so far as I was concerned. My brother was five years older than I, and he had a bicycle with drop handlebars and three-speed derailleur gears, whereas I rode standing up on my mother's bicycle, which was far too big for me. Even with the saddle lowered as far as it would go, I was unable to sit and pedal at the

[1] Even today I occasionally resort to this memory aid, when, in a condition of momentary disorientation, I forget which is left and which is right. Then I just imagine a bicycle handlebar in front of me, apply the handbrake, and I know exactly which is which. I would never dream of getting on a bicycle where the handbrakes were mounted on both sides, still less on the left.

same time, I either sat or I pedalled, which made for an extremely inefficient, exhausting and, as I was all too well aware, ridiculous mode of cycling: first I pedalled hard in a standing position to get some speed up, then I launched myself up into the saddle, I sat on the wobbly seat, going at full tilt, with my legs extended or pulled up, and remained like that until the bicycle had almost come to a stop before lowering myself on to the still-rotating pedals to work up fresh momentum. With that spasmodic technique, I made the journey from our house, along the lakefront, through Obernsee, to Miss Funkel's in twenty minutes, so long as – well, so long as nothing got in the way, literally. But of course plenty of things did. The thing is, that while I could ride, steer, brake, mount and dismount, etc., I couldn't bear to overtake, be overtaken, or pass anyone coming the other way. As soon as I detected the sound of a car approaching from in front or behind, I would brake

right away, dismount, and wait until it had passed. When other cyclists appeared in front of me, I stopped and let them ride by. My method of passing pedestrians was to dismount just behind them, run past them, pushing the bicycle, and only get in the saddle again when I was safely a long way ahead of them. I needed to have a completely open road ahead of me and behind me in order to cycle, and preferably no one to watch me doing it either. And then, last but not least, halfway between Unternsee and Obernsee there was Mrs Hartlaub's dog, a horrible little terrier who used to hang around on the road and hurl himself yapping at anything with wheels. The only way of surviving his onslaughts was to make for the side of the road, cleverly come to a stop alongside the garden fence, grab hold of a fence post, and sit trembling in the saddle with drawn-up legs, waiting for Mrs Hartlaub to call her mutt off. No wonder then, that under these conditions

twenty minutes was often not enough to get to the far side of Obernsee, and so, just to be on the safe side, I would regularly leave home at half-past two, to be sure of getting to Miss Funkel's in reasonably good time.

When I mentioned just now how Miss Funkel occasionally called on her mother to hand out biscuits to her pupils, I was careful to add that this only happened on certain very rare occasions. It was hardly commonplace, because Miss Funkel was a strict teacher, and very hard to please. If you'd skimped your homework or played a succession of wrong notes during sight-reading, then she would start wobbling her head around in a menacing fashion, her face would redden, she would jab her elbows into your side, click her fingers with irritation, and suddenly burst out yelling and calling you terrible names. The worst of these occasions occurred when I'd been her pupil for about a year, and it was so upsetting to me

that thinking about it still makes me nervous even now.

It began with my being about ten minutes late. Mrs Hartlaub's terrier had kept me pinned to the fence, I'd encountered two cars, and had had to pass four pedestrians. By the time I got to Miss Funkel's, she was already stalking up and down the room, wobbling her head, with red face and clicking fingers.

'Do you know what time it is?' she growled. I made no reply. I didn't have a watch. I wasn't given my first watch until my thirteenth birthday.

'There!' she cried and snapped her fingers in the direction of the corner, where the grandfather clock was ticking away over Ma Funkel's inert, sedentary form. 'It's almost a quarter-past three! What have you been up to this time?'

I began mumbling something about Mrs Hartlaub's dog, but she wouldn't even let me finish. 'A dog!' she said, cutting me off.

'Playing with a dog! I don't believe it! You'll have been eating ice-cream! I know your sort! Forever hanging around Mrs Hirt's kiosk, just set on stuffing yourselves with ice-cream!'

Now that was terribly unfair! To accuse me of hanging around Mrs Hirt's kiosk and buying ice-cream! When I didn't even get any pocket money! My brother and his friends, they got up to things like that. They spent every penny of their pocket money on ice-cream from Mrs Hirt. But not me! Every single ice-cream I got, I had to wheedle out of my mother or my sister! And here I was, being accused of hanging around Mrs Hirt's kiosk, stuffing myself with ice-cream, when actually I'd been cycling to my piano lesson, in the sweat of my brow and in the teeth of enormous difficulties! I was speechless at such a display of meanness, and promptly began to cry.

'Stop that whimpering!' snapped Miss Funkel. 'Get your music out, and show

me what you've learned. I bet you haven't bothered to practise again!'

As it happened, she wasn't entirely mistaken. I'd hardly had a moment to practise in the past week, partly because of having other important things to attend to, and partly because the études she'd set me were horribly difficult, fugue-like things in canonic tempo, the right and left hand far apart, with sudden stops here and there, in an unnatural rhythm and peculiar intervals, and on top of it all, the whole thing sounded horrid. The composer's name was Häßler, if I'm not mistaken – drat him!

Even so, I think I would have made a reasonable fist of getting through the two pieces, but for the fact that all the disturbances on the way – principally the attack by Mrs Hartlaub's terrier, followed by Miss Funkel's ticking off – had completely frazzled my nerves. So there I was, sweating and trembling, my eyes dimmed by tears, at the piano, eighty-eight keys and Mr Häßler's

études in front of me, Miss Funkel's hot, wrathful breath on my neck ... and I couldn't do it. I got everything wrong, I confused bass and treble clefs, whole notes and semitones, quarter and eighth rests, left hand and right. Before I had even reached the end of the first line of the score, the keys and notes were spinning in a kaleidoscope of tears, and I dropped my hands and started sobbing uncontrollably.

'As I thought!' hissed the voice behind me, and a fine spray of saliva drizzled on my neck. 'As I thought. Turning up late for lessons he's good at, and eating ice-cream and inventing excuses! But as for doing his homework, that's another matter altogether! But you'll learn, my boy, you'll learn!' And with that she shot round from behind me, plonked herself next to me on the bench, grabbed my right hand in both of hers, and, pulling out one finger at a time, jammed them down on the keys in the way Mr Häßler had envisaged. 'That one goes there! That one

there! That one there! Thumb here! Middle finger there! That one there! And that one there . . . !'

Then, when she'd sorted out my right hand, she got to work on the left, by the same method: 'That one there! And that one there! And that one there . . . !'

She manhandled my fingers so determinedly, it was as though she wanted to drill the étude into them, physically, note by note. It hurt quite a bit, and went on for about half an hour. Then she finally left off me, snapped the score shut, and hissed, 'By next week, you'll know it, laddie, and not just by sight, you'll play it by heart and allegro, or else!' And then she opened a thick, four-handed score and banged it down on the music stand: 'And now for the remaining ten minutes of the lesson, we'll play some Diabelli, so that you'll learn to read music at last. Woe betide you if you make any mistakes!'

I nodded obediently and with my sleeve

wiped the tears from my face. Diabelli was a friendly composer. He wasn't a fugue-merchant like that awful Häßler. Diabelli was easy to play, simple, elementary even, but he always sounded highly impressive. I loved Diabelli, even though my sister sometimes said, 'Even if you can't play the piano at all, you can still play Diabelli.'

So we played Diabelli for four hands, Miss Funkel on the left tootling away on the bass, and me on the right playing the two-handed descant in unison. For a while it went swimmingly, I felt my confidence returning, I thanked God that He had created the composer Anton Diabelli, and finally, in my relief I lost sight of the fact that the little sonatina was in the key of G major and so an F sharp had been marked at the beginning; what that meant was that in the long run you couldn't stay safely on the white keys, but that in certain places, and without any further warning from the score in front of you, you had to strike a black note, namely

that F sharp immediately below G. So when the F sharp appeared in my part for the first time, I failed to recognise it as such, but hit the nearest F natural instead, which, as any lover of music will appreciate, resulted in an unpleasant discord.

'Now isn't that typical!' hissed Miss Funkel and stopped playing. 'Typical! The first hint of a difficulty and the maestro misses! Have you no eyes in your head? F sharp! It says so in black and white, here! Got it! Now, from the top! One-two-three-four . . .'

How it transpired that I made the same mistake a second time is still a mystery to me today. I must have been so intent on *not* making it that I sensed an F sharp lurking behind every note, would probably have liked nothing better than to play a succession of F sharps, had to force myself not to play F sharp, not yet, not yet . . . until . . . well, until I once again played F natural instead of F sharp at the same place.

The blood shot to her face and she

screamed, 'I don't believe it! F sharp, I said, confound it! F sharp! Don't you know what F sharp is, you clot! It's this one here!' – plink plink – and with her index finger, whose tip was as broad as an old penny after three decades of piano lessons, she hammered on the black note below the G. '*That*'s F sharp . . . !' – plink plink – '*That* . . . !' At which point she had to sneeze. She sneezed, wiped her index finger across her moustache, smote the black key two or three more times, screeching, '*That*'s F sharp, *that*'s F sharp . . . !' And then she took her handkerchief out of her sleeve and blew her nose.

But my eyes remained glued to the F sharp. I turned pale. There, on the front of the key was a fingernail-long, pencil-thick, squiggly, shiny, yellow-green portion of slimy fresh snot, evidently originating from Miss Funkel's nose, expelled on to her moustache when she sneezed, from there via the wiping motion to her index finger, and from there on to the F sharp.

'Take it from the top!' she growled across at me. 'One-two-three-four ...' and we started playing again.

The following thirty seconds were among the worst of my life. I felt the blood draining from my cheeks and a cold sweat break out on my neck. My hair stood on end, my ears were alternately hot and cold, and finally went completely deaf as though they were both blocked, I could hardly hear Anton Diabelli's pretty melody, which I was playing quite automatically, without looking at the score – after two repetitions, my fingers knew their way around – I just couldn't take my eyes off the slim black key below G, which had Marie-Luise Funkel's bogey sticking to it ... another seven bars to go ... another six ... it was impossible to press the key without planting my finger in the middle of the snot ... another five bars, four ... but if I didn't play it and played F natural instead of F sharp for the third time, the consequences ... another three

bars ... Oh God, I need a miracle! Say something! Do something! May the earth swallow me whole! Smash the piano! Let time go backwards, anything so I don't have to play that F sharp! ... two bars to go, one ... and God said nothing and did nothing, and the last terrifying bar arrived, and – I remember exactly – it was made up of six eighths, descending from D to the F sharp, ending in a quarter-tone G above ... for my fingers it was a descent into Hell, this sequence of eighths, D-C-B-A-G ... 'The F sharp now!' she screamed next to me ... and, knowing full well what I was doing, I defiantly played F natural.

I hardly had time to pull my fingers off the keys before the piano lid came crashing down, and Miss Funkel shot up like a jack-in-the-box beside me.

'You did that on purpose!' she shrieked, her voice cracking with fury, and so loud that, in spite of my deafness, my ears were ringing. 'You did that on purpose,

you cheeky devil! You snotnose! Hooligan, you ...'

And she stamped round and round the dinner table in the middle of the room, bringing her fist down on it with every other word.

'I won't be led by the nose by you, do you hear! Don't imagine for one moment I'm going to let you get away with this impertinence! I'll telephone your mother. I'll telephone your father. I demand they give you such a thrashing that you won't be able to sit down for a week. I want you shut up at home for the next three weeks, and I want you to practise the scale of G major for three hours every day, and D major and A major too, with F sharp and C sharp and G sharp, until you can play them in your sleep! I'll teach you to muck around with me, you little monkey! I'll teach you ... If I had my way I'd give you a whipping ... right now ... myself ...'

And with that she finally choked with

fury, waved both arms about in the air, her face turned purple, it seemed she would explode any second, and then she grabbed an apple from the bowl of fruit on the table, took aim and hurled it across the room with such force that it smashed on the wall, and left a brown stain next to the grandfather clock, just over her mother's old tortoise head.

Whereupon, as if some ghastly ghostly mechanism had been triggered, something stirred in the tulle mountain, and the old crone's hand emerged from the folds of her robe, and set off in the familiar direction of the biscuits . . .

But Miss Funkel never saw that, only I did. She had thrown open the door, pointed with arm outstretched and wheezed, 'Pack your stuff and get out of here!' and as I stumbled out, crashed the door shut behind me.

I was trembling all over. My knees were shaking so badly that I was hardly able to walk, never mind ride a bicycle. With

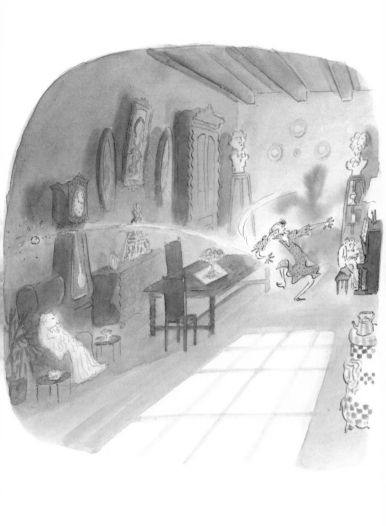

trembling hands I jammed my scores on the carrier and started pushing. As I pushed, dark thoughts seethed in my brain. The thing that plunged me in turmoil, that drove me into such a fevered state of agitation, was not Miss Funkel's telling-off; nor the threat of a beating and house-arrest; it wasn't fear of any kind. What it was was the devastating realisation that the whole world was unjust, malign, rotten and mean to the core. And the ones that were to blame for its dirty rotten meanness were the others. All of them. Every one without exception. Starting with my mother, who refused to buy me a decent bicycle; my father, who backed her up; my brother and sister who sniggered at me for having to cycle standing up; that disgusting mutt of Mrs Hartlaub's who was always ambushing me; the pedestrians who clogged up the lake road, thereby forcing me to arrive late; the composer Häßler with his boring and unplayable fugues; Miss Funkel with her false accusations and her disgusting

snot on the F sharp . . . everyone up to and including God Himself, yes, the so-called Almighty, who on the one occasion I turned to Him in my need, merely kept a cowardly silence and allowed an unjust fate to run its course. What did I need all that rabble for, when they had united in a conspiracy against me? What was I doing in such a world in the first place? In such a mean, low-down world. Let the lot of them choke on their own meanness! Let them wipe their own snot wherever they felt like! So long as they left me out of it. I'd had enough. I was going to kiss the world goodbye. I was going to kill myself. Right away.

As soon as I had formulated this plan, my heart felt lighter. The notion that I only needed to 'depart this life' – as the process was charmingly known – in order to be shot of all the injustice and nastiness at a stroke, had something amazingly comforting and liberating about it. My tears dried. My trembling stopped. There was room for hope in

the world once more. Only it had to be right away. Now. Before I could change my mind.

I climbed on to the pedals and rode off. In the centre of Obernsee for once I didn't take the road home, but turned right, away from the lake, rode up the hill through the woods and rattled down a rough track to my road to school, close by the transformer hut. There stood the biggest tree I knew, a mighty old red spruce. That was the tree I would climb, and from whose top I would plunge to my death. No other type of death occurred to me. There was drowning and stabbing and hanging, of course, and I knew it was possible to suffocate or electrocute oneself – this last was once explained to me in considerable detail by my brother, 'But you need a zeroaxial conductor for that,' he said, 'that's the alpha and omega of it, without a zeroaxial conductor nothing would happen, otherwise the birds on the wires would all be dropping dead the whole time. And as you know, they don't.

And why not? Because they haven't got a zeroaxial conductor. Theoretically, you can even dangle from a hundred-thousand-volt, high-tension wire, and nothing would happen to you – without a zeroaxial conductor.' So much for my brother. To me it was all far too complicated, electricity and all that. Anyway, I didn't have a clue what a zeroaxial conductor was. No – the only way for me to go was from the top of a tree. Falling was something I knew about. Falling held no terrors for me. It was the only possible way for me to go about my death.

I leaned the bicycle against the transformer hut, and made my way through the undergrowth to the red spruce. It was so ancient that all its lower branches were gone, so I had to climb a nearby fir tree first, and climb across. After that, it was easy. The thick, firm branches were like rungs on a ladder and I climbed and climbed and didn't stop until daylight suddenly broke through the twigs above me, and the trunk had become

so thin I could feel it gently swaying. I was still a little way below the crown, but, when I first looked down, I could no longer see the ground, so thick was the greeny-brown carpet of needle clumps and branches and cones at my feet. I couldn't possibly jump from here. It would have been like jumping from above the clouds – the appearance of a soft and welcoming bed, and an ensuing plunge into the unknown. But I didn't want any plunge into any unknown, I wanted to see with my own eyes where and how and past what I would be falling. I wanted my fall to be the classic free fall of Galileo's experiments.

So I started to climb back down into the dimmer regions, looking all round the trunk at every level for a gap that would permit a clean, unbroken fall. Just one or two branches down, I found one, an ideal air corridor like a mineshaft, plumb to the ground, where the knotty protruberant roots of the tree would guarantee a hard and

unquestionably fatal impact. All I had to do was to move out from the trunk a little way, slide along the branch before jumping, in order to plunge into the depth completely unhindered.

I slowly crouched down into a sitting position on the branch, and took a breather, resting against the trunk. Until that moment, I hadn't had a chance to reflect on what I was doing, so much was I preoccupied with the doing of it. Now, though, with the critical moment at hand, my thoughts came back to me, they swarmed towards me, and, after once more condemning the whole wicked world lock, stock, and barrel with all its inhabitants, I directed them towards the rather pleasanter theme of my own funeral. Oh, what a splendid funeral it would be! The church bells would ring, the organ would intone, the cemetery at Obernsee would scarcely be able to contain all the mourners. I would be lying in state in a glass coffin, bedded on flowers, there would

be a little black horse pulling the hearse, and all around there would be nothing but the sound of tremendous sobbing. My parents would be sobbing, my brother and sister would be sobbing, the children from my class, Mrs Hartlaub and Miss Funkel would be sobbing, friends and relatives would have come from far away in order to be able to sob at my funeral, and, as they sobbed, all of them would beat their breasts and wail and lament, 'Oh! We are to blame for the untimely demise of our dear and irreplaceable fellow being! Oh! If only we'd treated him better, if only we hadn't been so cruel and unfair to him, then he would still be alive now, the dear, good, gifted, lovely boy!' And by the graveside stood Carolina Kückelmann, and tossed me a bouquet and her last farewell look, and amid tears, her hoarse voice full of pain, she would say, 'Ah, my darling! My own one! If only I'd come with you that Monday!'

Sweet fantasies! I luxuriated in them, played

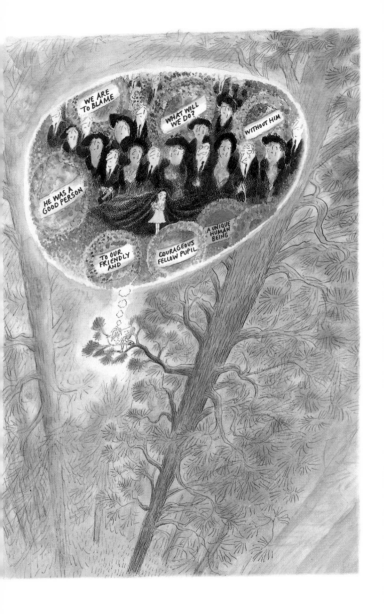

the funeral through again and again, with all sorts of variations, from the laying out to the tea and sherry afterwards, at which eulogies to me would be spoken, and finally I found the whole thing so moving that, while not actually sobbing myself, I did find my eyes moistening. It was the most beautiful funeral that had ever been seen in those parts, people would still be reminiscing about it in future decades . . . Just a pity that I couldn't really witness it myself, because I would be dead. Unfortunately there wasn't much to be done about that. If it was my funeral I would have to be dead. I couldn't have my cake and eat it. It was revenge *on* the world or going on living *in* the world. Revenge it was!

I let go of the trunk of the spruce. Gradually, inch by inch, I moved away from it with one hand on the trunk, half supporting myself, half pushing myself away, and the other gripping the branch I was sitting on. The moment came when I could only just touch the trunk with the tips of

my fingers ... and then not even with those ... and then I was sitting, without any lateral support, only gripping the branch firmly with both hands, as free as a bird over the drop. Very, very carefully I looked down. I estimated my height was about three times the front elevation of our house, which was thirty feet, so I was about ninety feet up. So, according to Galileo Galilei's Laws, that meant I was looking at a falling time of precisely 2.4730986 seconds[1] and thus a collision with the ground at a final velocity of 54.15 miles per hour[2].

I looked down for a long time. I felt the pull of the deep. I was succumbing to it. It seemed to be beckoning to me, 'Come

[1] This figure makes no allowance for wind resistance!

[2] Of course I didn't make this calculation to seven points of decimals while perched up the tree but much later, with the aid of a pocket calculator. I had heard of gravity at the time, but I didn't grasp its full significance, nor was I familiar with the mathematical formulae associated with it. At the time, my calculations were limited to a rough estimate of the drop, and the conclusion – based on various empirical evidence I'd gathered – that the falling time would be relatively long, and the collision speed correspondingly high.

on, fall!' It tugged at me with invisible strings. 'Come on!' And it was so easy, childishly easy. Just lean forward a little, just a momentary loss of balance – the rest would take care of itself . . . 'Come on, fall.'

Yes, I want to! I just can't quite decide when! Which point in time, which split second! I'm unable to say, Now! I'll do it now!

I decided to count up to three, the way we did when we raced each other or when we jumped into the water. When I got to three I would drop. I took a deep breath and started to count.

'One . . . two . . . ' And then I broke off again, because I wasn't sure if I should jump with my eyes open or shut. After a bit of thought, I decided to keep my eyes shut while I counted, keep them shut when I got to three and leaned out into the void, and only open them when I actually started to fall. I shut my eyes again and counted: 'One . . . two . . . '

Then I heard a tapping noise. It was coming from the road. Hard, rhythmic tapping, 'tack-tack-tack', at twice the tempo of my counting, so that there was a 'tack' on 'one', 'tack' between 'one' and 'two', 'tack' on 'two', 'tack' between 'two' and the impending 'three' – just like Miss Funkel's metronome: 'tack-tack-tack-tack'. It was almost as though the tapping was trying to put me off my counting. I opened my eyes and in that instant the tapping stopped and all I could hear was rustling, twigs snapping and a deep, animal panting – and there was Mr Sommer standing some ninety feet perpendicularly below me, so that if I jumped I would certainly have smashed the pair of us. I gripped my branch hard and didn't budge.

Mr Sommer stood there, panting. When he had recovered a little, he suddenly stopped and held his breath, jerking his head from side to side, probably to listen. Then he bent down and peered into the bushes on the left and the trees on the right, he prowled Red

Indian fashion once right round the tree, reappeared in his original place and looked around and listened out once more (but didn't look up!), and, having made sure there was no one following him, and no one to be seen anywhere around, in three swift movements he cast off his straw hat, his stick and his rucksack, and lay down flat between the roots on the ground, as in a bed. But he didn't rest in his bed, no sooner was he lying down than he emitted a long and ghastly sigh – no, not a sigh, because a sigh already affords some relief, it was more like a groan, a hollow anguished sound from deep within his chest, blending despair and longing for relief. A second time, this chilling sound, a desperate groan, as from an invalid racked with pain, and again no relief, no peace, not a second's respite, because he quickly picked himself up, reached for his rucksack, hastily pulled out his sandwich and tin water bottle, and began eating, gobbling, cramming the sandwich into him, stopping

between chews to look around suspiciously, as though some dreadful pursuer were hard on his heels, someone on whom he had gained only a small distance, getting smaller by the second, and who might appear in this very place at any moment. In no time at all, the sandwich had been wolfed down, a swig from the water bottle, and then more hectic rush and preparation for departure: the canteen stuffed into his rucksack, the rucksack shouldered as he was getting to his feet, hat and stick snatched up, and off at the double, panting, crashing through the bushes, rustling and snapping twigs, and then from the road that metronomic tapping of his stick on the hard asphalt: 'tack-tack-tack-tack-tack . . . ' in a rapid diminuendo.

I sat up in the fork of the spruce, pressing myself against its trunk, don't ask me how I got back there. I was trembling and shivering. Suddenly I no longer felt like leaping to my death. It seemed a ridiculous idea. I couldn't understand how such a stupid idea had ever

crossed my mind: killing myself over a bit of snot! Especially when I'd just been watching a man who all his life was on the run from death.

Five or six years must have passed before my next encounter with Mr Sommer, which was also the last. Of course I saw him on numerous occasions in that time – as he was always doing his rounds it would have been almost impossible not to have seen him on the road somewhere, on one of the many little lakeside paths, in the fields or in the woods. But I was no longer especially aware of him, I don't think anyone was especially aware of him, he had been seen so many times already that we tended to take him for granted. He had become so familiar to us all, he was like part of the landscape, and you don't go around exclaiming, Look,

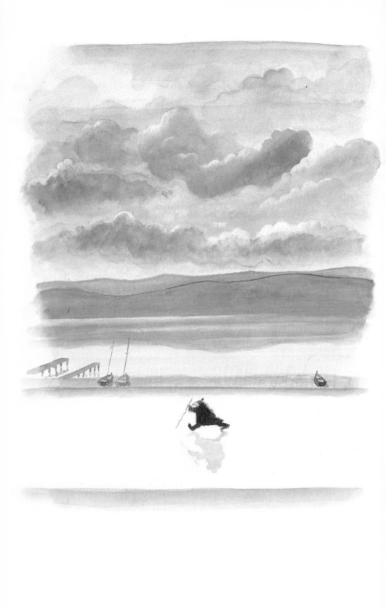

there's the steeple! I say, isn't that School Hill over there! Look, there goes the bus ...! Just occasionally, when I was going to the races with my father of a Sunday, we might pass him on the road, and one or other of us would quip, 'Look, there goes Mr Sommer – he'll catch his death ...' and even then we weren't really referring to the actual man in front of us or behind us, but more our own memory of the day of the great hailstorm many years ago, when my father had used the cliché.

Apparently his wife, the doll-maker, had died, but no one knew when or where, and no one had attended the funeral. He no longer lived in the basement of the painter and decorator Stanglmeier – Rita and her husband lived there now – but a few houses away, in Riedl the fisherman's attic. He was never there very much, Mrs Riedl said later, and then only for a short time, just enough to make some tea or get something to eat, before walking off again. Often he hadn't

come home for days on end, even staying away all night; where he'd been, where he'd spent the night, whether he'd slept at all, wherever it was, or whether he'd gone on wandering all night – nobody knew. Nobody much cared either. People had other things on their minds now. They were preoccupied with their cars, their washing-machines, their lawn-sprinklers, but not with the matter of where some old eccentric laid his head at night. They talked about what they'd heard on the wireless or seen on television the day before, or about Mrs Hirt's new self-service supermarket – not about Mr Sommer! So Mr Sommer might still pop up from time to time, but in the consciousness of his fellow men he was no longer there. Time had, as they say, drawn a veil over Mr Sommer.

Not over me, though! I'd kept pace with time. I was up with the times – at least so it seemed to me – and sometimes I even felt I was ahead of my time! I was almost

five foot seven, I weighed over seven and a half stone, and I wore size seven shoes. I was about to go into the fifth class at the Gymnasium. I had read all of Grimm and half of Maupassant too. I had smoked half a cigarette and seen two films about an Austrian empress in the cinema. Pretty soon, I would get a student card with the much sought-after, red 'over 16' stamp on it, and that would entitle me to go to A and AA films, and go out to restaurants and cafés until ten o'clock at night without being in the company of 'parents and/or responsible adults'. I could solve simultaneous equations, build a crystal receiver for medium wave, I knew the beginning of *De bello Gallico* off by heart, and the first line of the *Odyssey* too – though I'd never studied Greek in my life. On the piano I no longer played Diabelli or the detested Häßler, but such prestigious composers as Haydn, Schumann, Beethoven and Chopin, and boogie-woogie and blues

as well. When Miss Funkel blew her top now, I took it philosophically, or even with a hidden grin.

I hardly ever climbed trees any more. On the other hand, I had my own bicycle, my brother's old one, with drop handlebars and three-speed gears, and on it I smashed his old record of thirteen and a half minutes for the stretch from Unternsee to the Villa Funkel by fully thirty-five seconds, setting a new record of twelve minutes fifty-five seconds – timed on my own wristwatch. In fact – in all modesty – I had become something of a star cyclist, not just in terms of speed and stamina, but agility too. Riding with no hands, taking corners no hands, turning a hundred and eighty degrees while stationary or by braking and skidding, all that was a doddle to me. I could even stand up on the rack while moving – a pointless but artistically impressive accomplishment that speaks volumes about my new unlimited faith in the principle

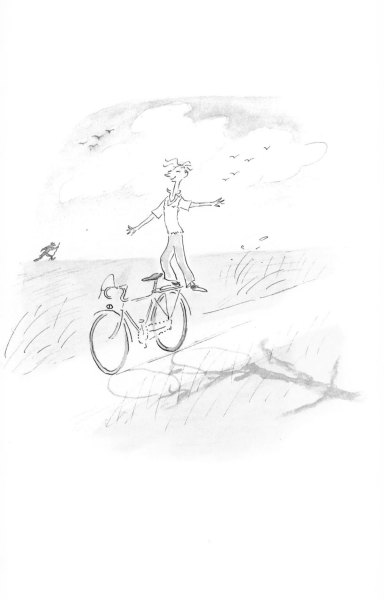

of angular momentum. In theory as well as practice, my reservations about cycling were a thing of the past. I was an enthusiastic cyclist. I thought cycling was almost like flying.

Of course there were still a few things that made life miserable for me even now, in particular a) the fact that I had no regular access to a wireless with VHF reception, which meant that I missed out on the crime thrillers that went out on Thursday nights between ten and eleven o'clock, and had to content myself with accounts of them from my friend Cornelius Michel on the school bus the next morning – which wasn't at all the same thing; and b) the fact that we had no television at home. 'I'm not having a television in the house,' decreed my father, who was born in the same year as Giuseppe Verdi died. 'Television is detrimental to the playing of music in the home, it's bad for the eyes, damages family life and generally leads to

imbecility.'[1] Unfortunately my mother failed to contradict him on the matter, and so, for the occasional enjoyment of such culturally significant events as *Mother Knows Best*, *Lassie* and *The Adventures of Hiram Holliday*, I was forced to go to my friend Cornelius Michel's house.

Irritatingly, all these shows were in the so-called early-evening programme, and didn't end until eight o'clock when the evening news came on. But I was expected home on the dot of eight, at table, and with my hands washed. However, it being impossible to be in two places at the same time, especially when there's a cycle-ride of seven and a half minutes from one to the other – to say nothing of washing hands – my television escapades gave rise to the classic

[1] There was one day in the year on which television was not bad for the eyes and did not lead to general imbecility, namely that day in early July on which the German Derby was transmitted live from the flat course at Hamburg-Horn. For that occasion my father would put on a grey top hat, drive to the Michels' in Obernsee, and watch the transmission from there.

conflict between personal inclination and duty. Either I had to leave seven and a half minutes before the end of the show – and miss the denouement of the drama – or I watched it to the end, arrived seven and a half minutes late for supper, and risked a row with my mother, and an extended lecture from my father on the harm television did to family life. That whole period in my life seems to have been characterised by such conflicts. You were forever being told that you should, must, mustn't, shouldn't . . . something was always expected, demanded, wanted from you: Do this! Do that! Don't forget! Haven't you done that yet? Haven't you been there yet? What kept you . . . ? Pressure, constant strife, lack of time, everything by the clock. How rarely they left you in peace in those days . . . But I don't want to start moaning, and banging on about all these conflicts in my adolescence. It's better just quickly to scratch my head, maybe tap my middle finger once or twice on the place

on the back of my head, and concentrate on what I'm obviously trying to weasel out of, namely my final encounter with Mr Sommer, and the ending of this story and his.

It was in autumn, after one of those television evenings over at Cornelius Michel's. The episode was boring, the ending seemed all too predictable, so I left the Michels' house at five to eight, in order to be home in reasonable time for supper.

Darkness had already fallen, only in the west over the lake was there a last grey glimmer in the sky. I rode without a light, partly because something was forever going wrong with it – if it wasn't the bulb, then it was the fitting or the wiring – partly because using the dynamo was such a drag on the wheel that it would have put a whole extra minute on my time back to Unternsee. Anyway, I didn't really need the light. I could do the trip in my sleep. Even on the blackest of nights, the asphalt of the road remained a little blacker than the garden

fences on one side of the road, and the bushes on the other, so you just had to keep heading into the blackest part of the dark to be safe.

So I was rushing through the early night, hunched low over the handlebars, in third, with the wind whistling round my ears, cool and damp and smelling of smoke in certain places.

Almost exactly halfway – at a point where the road leaves the lake a little way, and cuts across an old gravel pit, behind which the woods are massed – the chain came off. This, unfortunately, was a recurring fault with the otherwise excellent gear-system, caused by a worn spring that didn't give the chain enough tension. I had spent whole afternoons tinkering with the problem without managing to fix it. So I stopped, got off and crouched down beside the rear wheel in order to free the chain, which had gotten jammed between the gear wheel and the frame, and, by gently moving the pedals, pull it back

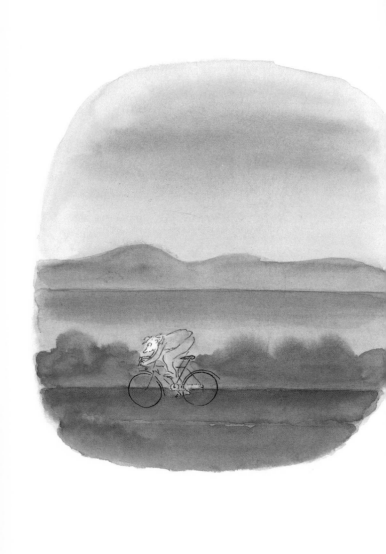

over the gear rim. I was so well versed in this procedure that I could do it quite easily, even in the dark. The only problem was that you always got your hands filthy with oil doing it. And so, once the chain was back on, I went over to the far, lake side of the road to wipe my hands clean on the large, dry leaves of a maple sapling. As I pulled the twigs down, the lake came into view. It was like a large, bright mirror. And there, on the edge of the mirror, stood Mr Sommer.

At first I thought he must be barefoot. But then I saw that he was actually in the water up to the tops of his boots, standing a couple of yards away from the shore, with his back to me, looking westward, to the opposite shore, where there was still one remaining strip of yellow-white light behind the mountains. He stood there as still as a fencepost, a dark silhouette against the bright surface of the lake, his long, undulating stick in his right hand, and his straw hat on his head.

And then, abruptly, he started walking.

Step by step, and every third step jabbing the stick down and pushing off, Mr Sommer walked into the lake. He walked as though he were walking on land, with that characteristic, purposeful haste of his, heading due west straight for the middle of the lake. At that point the lake shelves quite gently. After twenty yards, the water barely went up to Mr Sommer's hips, and by the time it was up to his chest, he was already more than a stone's throw away from the shore. And on he went, impeded in his haste now by the water, but still unstoppable, without a second's hesitation, obstinate, almost avid to make faster progress against the retarding element, then finally throwing away his stick, and rowing with his arms.

I stood on the shore and stared after him, with gaping mouth and saucer eyes. I must have looked like someone listening to a ghost story. I wasn't alarmed, rather perplexed by what I saw, riveted, failing to grasp the ghastliness of what was happening. To begin

with, I had thought he was just standing there, looking for something he'd lost in the water; but who ever gets in the water with his boots on to look for something? Then, when he marched off, I thought: He's taking a dip; but who ever takes a dip, fully dressed, at night, in October? And finally, as he went ever deeper into the water, I had the absurd thought that he meant to cross the lake on foot – not by swimming, not for a second did I think he was swimming, Mr Sommer and swimming simply didn't go together at all, no: to cross it on foot, hurrying across the lake floor, a hundred yards under the surface, three miles to the opposite shore.

Now the water went up to his shoulders, then it went up to his collar ... and he pressed on, further into the lake ... and then he rose again, he must have come to a small elevation on the lake bed, his shoulders emerged from the water ... and he carried on, not stopping, not now, further and further, and sank deeper, his throat, his

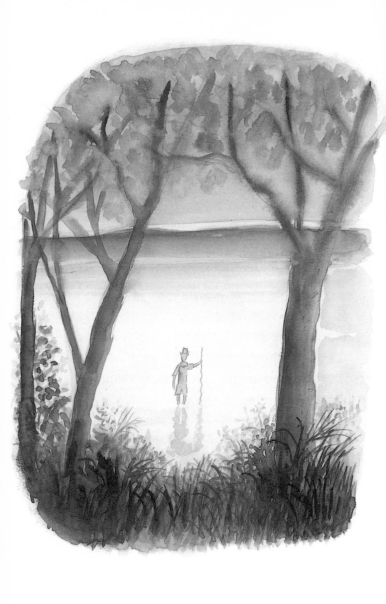

Adam's apple, past his chin ... and only now did it begin to dawn on me what was afoot, but I made no move, I didn't cry out, Stop, Mr Sommer! Turn back! I didn't run for help, nor did I look round for some means of rescue, a boat, a raft, a lilo, yes, I never moved my eyes – not for a second, not to blink – from the little dot of the head that was going down.

And then suddenly he was gone. Only the straw hat was floating on the water. After a horrible delay, half a minute, maybe, maybe a minute, a few large bubbles went up, then after that nothing. Only the ridiculous hat, now drifting off very slowly southwest. I followed it with my eyes for a long time, till it disappeared in the gloom.

Two weeks it took before Mr Sommer's disappearance was even noticed by anyone. Then, it was the wife of the fisherman Riedl who was worried about the monthly rent payment for her attic. Two weeks later, when Mr Sommer still hadn't turned up, she had a word with Mrs Stanglmeier, and Mrs Stanglmeier had a word with Mrs Hirt, who in turn asked all her customers. But as no one had seen Mr Sommer or knew anything at all as to his whereabouts, after a further two weeks, the fisherman Riedl decided to notify the police about the missing person. Weeks again passed until a small advertisement appeared in the local newspaper with an ancient passport

photograph from which no one could have recognised Mr Sommer, as it showed a young man with thick, dark hair, an alert expression, and a confident, almost cheeky smile on his lips. The caption under the photograph made public Mr Sommer's full name for the first time: Maximilian Ernst Egidius Sommer.

Then, for a while, Mr Sommer and his mysterious disappearance was the talk of the village. 'He was completely barking,' some said. 'He's probably gotten lost and can't find his way home. He's probably forgotten his name and where he lives and everything.'

'Maybe he's emigrated,' others said, 'to Canada or Australia. With his claustrophobia there wasn't enough room for him in Europe.'

'He might have lost his way in the mountains and fallen to his death somewhere,' still others said.

No one thought of the lake. And before the newspapers had even had time to go yellow, Mr Sommer had been forgotten again. No one

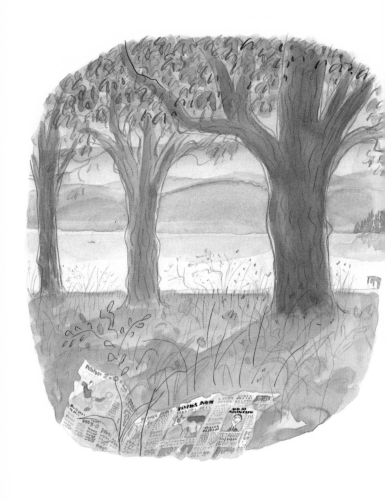

missed him anyway. Mrs Riedl removed his few belongings into a corner of her basement, and re-let the room to summer visitors. Only she didn't say 'summer visitors' because that would have sounded high falutin'. She said 'townsfolk' or 'holidaymakers' instead.

I for my part kept silent. I didn't say a word. That evening, when I got home very late and had to listen to the lecture about the terrible effects of television, I didn't say a word of what I had seen. Nor did I later. I didn't breathe a word to my sister, my brother, the police, not even to Cornelius Michel . . .

I don't know what it was that made me keep quiet so long and so obdurately . . . but I don't believe it was fear or guilt or a bad conscience. It was the memory of the groaning in the forest, of the lips trembling in the rain, the imploring words: 'Why don't you just leave me in peace!' – the same memory that kept me from calling for help when I watched Mr Sommer disappearing into the water.